C000092546

Making the News 2018

By Anna Brees

Copyright © 2018 Anna Brees

All rights reserved.

ISBN: 9781719948753

DEDICATION

This book is dedicated to my father Alan Charles Brees

CONTENTS

ACKNOWLEDGMENTS

To the students and lecturers from my psychotherapy course for the part they played in the direction of this book. To all those journalists I have worked with, news editors and producers at the BBC and ITV. To the numerous friends I have met via social media; for proof reading and feedback before publication. To brave police and political whistle-blowers Jon Wedger, Mike Veale, Lenny Harper, Stuart Syvret and Maggie Oliver.
Finally my biggest inspiration of all in the writing of this book - my father who taught me the meaning of selflessness, truth and justice.

INTRODUCTION

This book is an examination of what is Making the News in 2018, why some stories seem to get heard, and others don't.

Reflecting on my own experiences of working in a newsroom as a newspaper and TV reporter from 2000 until 2011, and, more recently, observing the impact of producing TV-style reports on my mobile device and boosting them on social media, this book is about the power of the message, the money to deliver it, and the instinct of truth and trust that follows.

When I worked as a journalist, we didn't have the all-encompassing social media presence in quite the same way as we do today. Journalism was an absolute necessity and existed as a point of contact, a person or organisation who collated and disseminated news. So, as I write this book in 2018, the question I pose is, do we really need journalists anymore?

Social media publications are collating and disseminating. Of course you have trust, reputation, and credibility, but we will go into that in more detail later.

However, the issue of truth and trust has never been more in the spotlight.

I could see it was all about trusting the vehicle from where the message comes and looking at the power that message had already gained (usually in terms of views).

After working for the mainstream media from 2000 until 2011, I had taken on an admin role as a project co-ordinator for the National Union of Journalists Training Wales and started training part-time to become a psychotherapist. I had three small children and, as a single parent, this role alongside the training worked very well in allowing me to be around for them.

However, after seven years in that role, my children were older, and, with more time on my hands, I felt I had to make a decision about putting my energy, passion, and broadcasting skills into a new venture.

So, I finished my job at the National Union of Journalists in 2017, and I asked myself whether I was really needed back in the newsroom.

A part of me had to reluctantly accept that perhaps I was redundant. By my own admission – did people really need me to collect the news and deliver it to them, with my spin, unconscious bias, and agenda?

As hard as it is to admit it, yes, I did have an agenda. I didn't think I did during my broadcasting career, but, having completed two years of psychotherapy training, I became very well aware I did... we all do.

So do I go back to what some would call the anachronistic regional half-hour programme, where daily news is captured and delivered in 30-minute excerpts, or do I do something unique and teach people to define their own truth using their mobile device? Could I use the techniques I mastered during my broadcast journalism

career to help people create TV with a smartphone or tablet?

I was born in 1976, and I recently looked back on some adverts from the 1980s, and (myself included) I think we all forget how grainy the picture quality was. If you know anyone with a VHS cassette player, take a look at that and it will give you an idea. Yet even an iPhone 5, which you can pick up second hand for £65, can produce a better quality picture than we all watched back then.

I was brought up in the four-channel era, and any TV was great if it was planned, well thought out, and original. The adverts were great, I loved it all.

So here we go, it is 2018 – we all have a mobile phone that produces better video than any camera from the 1980s, even 90s and early 00s. So what are we going to do with them?

1 SOCIAL STATUS

So my story starts in 2017, while working part-time for the National Union of Journalists and studying to be a psychotherapist. I had become more and more fascinated by what was happening in the media. So I put my psychotherapy training on hold, two years into a five-year course, I was compelled to. The journalist within me came back… the investigative, truth-seeking, journalist.

I had been watching a lot of alternative news. I heard many people claiming they had the truth, their opinion was right, and their evidence was too. Some of the broadcasts and articles appeared very convincing, but I always wondered why they had not appeared in mainstream publications.

So, in 2017, I felt I was being beckoned back to teach and investigate. Not working for the mainstream media this time, but for myself and for the people, as a TV reporter on social media.

I wondered if I could help citizen and community journalists by teaching them how to use their mobile devices to capture the truth. I also wanted to help others, such as small-business owners, market themselves better via video.

Everyone has a smartphone device, so all they needed was a bit of guidance. They had the equipment in the palm of their hands, pretty much in their possession 24/7.

So I first started my journey by filming and editing videos on my smartphone that looked like mainstream TV reports. Just like the crafted television packages I would do when working for ITV in Birmingham and the BBC in Southampton.

I only posted these videos to Facebook, YouTube, LinkedIn, Instagram, and Twitter, but it was confusing people and I was getting a good reach, I was called disruptive very early on. An influencer, an innovator. I ended up winning innovation awards at two large business events within months of setting up my business.

Everything I did was on my iPhone and would take no longer than two hours from start to finish. I would film my shots, then edit in the car, add my voice-over (often in a toilet cubicle, or my car, as they make a quiet sound booth), then put them straight to broadcast on all of those social media channels. Using my BBC voice but all on a mobile. (What did people think, I wondered - what the hell is she doing? Did the BBC sack her? She looks and sounds like a TV reporter).

People would say to me: 'It sounds like I am watching the TV but it is Facebook.' Well that was my aim, because if I can sound and look like I work for the BBC but I am talking from Facebook, YouTube, Instagram and Twitter, so can everyone else using their mobile phones.

That voice was not hard to develop. Anyone can do it, it just takes time.

When I watch documentaries on social media now, I realise how important that accent is. A strong broadcast journalist voice-over can really make nonsense seem like the truth. It could be baseless, unchecked, drivel – but that voice – the BBC/ITV reporter voice, can make anyone believe anything. The voice is the voice I had, and I soon started realising, when it came to the media, people were choosing their own reality.

While I began this training I stopped watching terrestrial TV in 2017, and pretty much only watched user generated content (UGC) on social platforms like YouTube, and this had a huge impact on my interpretations and definitions in my world. Beauty, truth, success, courage, all of these words had a different meaning to the content creators on YouTube, and that was having a direct impact on my life.

My definition of truth, and by choosing what I wanted to watch and believe, I was very much choosing my own reality.

So, after creating lots of videos with my mobile I then started my training courses in October 2017. I was teaching freelance marketers and journalists, communications and PR professionals, and small- to medium-sized enterprises how to communicate via video using their devices. Teaching them how to create short-form video for social media. One attendee, a campaign manager for the National Lottery, said a video filmed on his mobile could get 20,000 views, compared to a professional production costing £1,000 getting just 300

views. It was the content, not the quality, that seemed to pull the viewer in.

My training in this area was really taking off, and I loved it.

Alongside those courses, I created a support network, a Facebook group called Video Virtual Network, and could see people who had never even tried to do live broadcasting or a voice-over come out of their shells. Their confidence grew each time they produced a video, or did a live broadcast through the group. One chap in particular was incredibly camera shy, but within three weeks he was creating crafted edited video packages with confidence and finesse.

He reminded me of me, back in 2001 when I started out, and my first job in TV was a reporter for Channel TV (the ITV regional news for the Channel Islands). The first time I did a piece to camera was at a bus station in Guernsey. After an hour of failed attempts, I looked at the cameraman and announced I was to hand in my notice, that this was not the career for me.

I just could not do it, I was overwhelmed and intimidated. The public walking past looking at me, the cameraman's impatience increasing. After a while he found it very amusing, I didn't - I thought the dream was over.

Anyhow, I managed to muster up something and eventually did present a take that could be used. Over time I got better.

Just like the people in my Facebook group, I got better over time. It was new experiences and different managers and newsrooms in different parts of the country that helped me to progress.

I was in the Channel Islands for three years and then I moved to ITV Central in Oxford. I knew I had to up my game and again the nerves came back. More because I was broadcasting to a bigger audience, and it was a much harder job to get, working as TV reporter and presenter in England.

The newsroom was full of graduates from top universities, and the boss a well-known editor, Ian Rumsey, who had been married to Kate Garraway (Ian later went on to re-launch ITV's new breakfast show Daybreak in 2010). So I was even more intimidated than usual.

So those thoughts raced through my mind even more. How do I sound? How do I look? Am I good enough? Am I saying the right thing? Nerves, anxiety, excitement, terror. I got a lot better over time, thanks to a lovely encouraging bunch of people, some of whom remain friends to this day.

I was pushing myself, to be honest. I was very shy but I had a passion and spirit to do it... and do it well.

I had a talent for presenting and I really enjoyed it. Over time I got better, and within six months I was presenting the main news bulletin.

Fast forward to 2018, and now I am seeing the same progression within this Facebook group and my students, I can see others improving at a rapid rate, just in the same way that I did. Nervous and shy, but getting better over time. Video Virtual Network is the name of the Facebook group and it is skilling them up, and, more than anything, providing a safe environment to try new things, where everyone is starting from scratch with video.

There is the basic social media live where you just talk to camera, and then there is the slightly more planned broadcast, with interviews, events and props involved, even singing and dancing.

It is a progression as people's confidence grows, and these presentations can become more and more sophisticated.

However, I have seen a lot of people with a glass of wine in their hands and a dog barking in the background get the live broadcast very wrong. I was lucky as I had content and direction working in TV.

When we go live, we should always think what value will this have to the audience, and always be aware of our reputation. If we say something that is not true, or align ourselves with someone who has a bad reputation, then we will suffer. If we continue to post live broadcasts and visual content with little value to the audience, then they won't return.

So this was the start of my new training career in mobile video. I was really enjoying passing on those professional

broadcasting skills I had learnt to others. Seeing them develop in exactly the same way I had.

2 WHO'S WATCHING

Now let us talk about style and confidence when it comes to video.

At the moment there is very much a feel, tone, and mood to video on social platforms like YouTube - the vlog, as opposed, for example, to the news item on the BBC.

My son, who is nine, is a very good vlogger, and he mimics all the YouTube channel vloggers who have millions of subscribers. I hear his voice change from a UK English-speaking boy to an American when he presents to camera, full of passion, humour, and energy. It is funny to hear, and he does what I did – he mimics.

I, like him, have a TV voice and a real voice. My son is copying, just like I copied Mary Nightingale or Fiona Bruce when I read a news bulletin - it is essentially acting. But, over time, I developed my own presenting style. But it's not really my voice - which has a Forest of Dean and South Wales twang (where my mother and father are from).

So let us look at these two voices, and ask ourselves if we have two, or maybe even more?

When I was younger, my mum always answered the phone in a different voice, depending on who it was. And, stay with me on this one, as it is a very important element to live broadcasting and presenting. Who are we when we

talk on camera, and is it a different person to that who you meet in real life?

Think about the following. How would you feel about yourself if you were being interviewed by the following:

1. For the BBC Ten O'clock news?

2. For your BBC local radio station?

3. For your child's school project?

4. To be quoted in your local newspaper?

5. Doing a Facebook Live to just your friends?

6. Doing a Facebook Live for your business page?

7. Doing a Skype call with a stranger?

8. Doing a Skype call with a family member?

9. Doing a personal voice memo on your phone?

Think about all of these scenarios and imagine how you would feel in each situation. What is going on in your mind, what are your thoughts, and how do they affect your speech and body language?

When I worked for ITV Central in Birmingham, sometimes reporters had to do live broadcasts for the national news because they did not have a reporter in the area. For example, if there was a story in Birmingham that needed to be covered for the national news. So they would come to one of our regional reporters live and I could see and feel the additional nerves immediately.

I saw reporters from small TV stations in the Channel Islands go to larger stations and they would clearly be more nervous. This was for one reason, and one reason only, the audience was bigger.

I mostly saw those nerves pass in time, but sometimes they didn't and I could see the presenter being demoted to a smaller audience, for example, from the national news to ITV London, or the breakfast bulletin.

It was because they couldn't overcome those nerves, they stopped being natural. If you are not relaxed as a news presenter then people don't feel relaxed watching you. Trust and confidence can be lost in a TV reporter or commentator who looks uncomfortable, or out of their depth.

However, when you do overcome that fear, you can go from regional TV audiences of 100,000-200,000 viewers to national audiences of two to three million without changing how you sound. While staying confident, relaxed, and authoritative, then you can go far in your career as a broadcast journalist.

When I say 'be successful', that tends to mean reaching the bigger audience. Reaching that bigger audience means you have more influence and get more money.

You have to think what you want as a journalist, and this wasn't my motivation. I fell into TV journalism by accident. I wanted to be a print journalist, as deep down I knew I was a truth-seeking investigative journalist and felt more free in the written word. I wasn't very

confident on camera and felt this would distract me from my ability to do great journalism, as I'd be concentrating more on how I looked and sounded.

However, early on in my print journalism career I was demoted to the ad section of the Guernsey Press, writing advertorial sponsored features (very boring), so it was time to reassess my journalism career.

In the Channel Islands you don't need any qualifications to be a journalist. However, in the mainland UK, you do. So, at the age of 23, when I could choose to do a newspaper or broadcast qualification diploma, I decided to do the latter. But, as I will explain later on, for me and for many others the ego certainly became an issue.

So if you are broadcasting live or creating video what is your voice and what is your message?

For me, now at the age of 41, my mission is to teach everyone to become a TV journalist using their smartphones. But how can I do this? I studied journalism for nine months. How will others become qualified to do what I did, just by doing a few online training courses or attending one of my workshops?

A lot of what I covered during my Broadcast Journalism course in 2001 is now out of date.

The law, I would say, is the most important area now - defamation, libel, privacy, contempt of court, copyright - along with some basic principles in journalism, being fair

and honest, and always giving the other side of an argument.

The most important thing is accuracy and truth, if you mess up on this you lose trust, and quite rightly so. Double-check and triple-check everything. If you get it wrong, own up and apologise immediately.

In a Twitter post I said I had been removed from a shopping centre in Cardiff after doing an unauthorised live broadcast(testing the boundaries of what the centre deemed to be OK). But that was not true, they asked me to stop filming and request permission from the manager's office.

So I apologised and corrected that statement. This is so important. When you make a mistake, own up and say sorry.

I had exaggerated this story for effect, and it was unnecessary. I was asked to stop filming and get permission, I wasn't thrown out of the shopping centre.

Who is perfect? Who never makes a mistake? We all do, and to expect people not to is an unrealistic and unattainable expectation. In politics and the mainstream media, I see this all the time, the expectation of perfection which simply cannot be achieved. My advice for this, as a journalist, is simple. As soon as you realise you have made a mistake, own up to it and apologise, and explain how it happened. We all make mistakes, and I can absolutely guarantee that you will.

Being a good journalist is about building a brand, and that brand is you – you need to create a relationship of trust, people need to know, like, and trust you. Whatever message you are trying to portray, make it newsworthy and interesting. If you are a business owner, the last thing you should do in your videos or live broadcasts is sell.

For example, if you are running an online toy shop and the big craze this year is putty and slime, do a feature for parents on how to get it out of the carpet and other materials.

If you run events, do a video feature on all the things you need to plan a great event.

Your communication with others then has value, you are contributing something free and valuable and people will know, like, and trust you because of it.

Make it informative, fun, engaging and entertaining, and full of personality. Be yourself and people will know, like, and trust you, and then sales and profits will follow.

If you get it wrong from the outset, it is quite difficult to then pull it back. Get it right from the beginning, and your influence will grow.

3 THE MEDIUM

There is a healthy debate underway within the journalistic community about what makes a journalist. For example, in a village near to where I live in the Vale of Glamorgan, in South Wales, a semi-retired man in his 80s has 1,000 people on his email newsletter and sends out daily reports of what is happening in the village, basically forwarding on other people's emails of interest.

He has deemed certain communication inappropriate, although none of us really knows what this is. If he posts a controversial comment, he always puts his view underneath. Quite a few people, myself included, have sent him information which he has not published.

Is he a journalist? Yes, I guess he is.

So let us try to imagine a world when everyone becomes a journalist, which is what is happening now.

What is social media? The feeling is that there is the mainstream media and TV, and then social - communication between friends and family, and business contacts.

It implies that the social media reach is slightly contained and limited in comparison to the mainstream.

Let's look at what the actual word media means:

The word media comes from the Latin plural of medium.

- the main ways that **large numbers of people receive information and entertainment**, that is TV, radio, newspapers, and the internet

- **the means of communication,** as radio and TV, newspapers, magazines, and the Internet, **that reach or influence people widely**

- **the main means of mass communication** (TV, radio, and newspapers) regarded collectively:

These are three different dictionary definitions. Each one suggests the same thing... it is about numbers. The main means of mass communication, so it is about power in numbers.

But there are many news organisations on YouTube, such as Infowars and Breitbart, which are being called alternative news. They have similar viewing figures to mainstream news publications.

It is the mainstream calling them alternative, and I think this will change over time. The mainstream's definitions and opinions on this are vitally important, as they are the guide for society as to what it is OK to say, and what is not OK to say. For example, believing in aliens, not believing the official version of events relating to 9/11, JFK's death, etc.

The mainstream are calling the alternative the 'alternative media'. The public may soon want to challenge that.

I can't tell you the number of times people have whispered to me in public, what do you think about the Illuminati, 9/11? It has happened to me twice, once with a security guard at a shopping centre in Cardiff, and another time at the Apple store, again in Cardiff. Both whispered it to me, as they didn't want their employers to hear. Their alternative news source had given them some information and the confidence to share it with me. All I said to them was that I loved YouTube for great investigative documentaries and that I had an open mind. I didn't mention the Illuminati or 9/11 .

For me, when it comes to journalism and trusting a story, I have always found it difficult to trust any information without knowing the source of that information intimately - how can you trust it to be true?

I know a lot of the journalists, working at, for example, Sky News and ITV's Good Morning Britain, and they are the kind of people I trust. But they are just disseminating information. I know they do their best to check sources, but it is difficult.

For example, working in a newsroom, the calls would come in from the public with various stories, but more often than not you would not follow them up because they'd be considered to be too much work to verify, and especially at ITV we just didn't have the staff or resources to invest a lot of time into these potentially great stories. On the whole we didn't trust people calling in with a story unless they appeared to be a professional or at least had a professional verifying their story.

They would need some good solid evidence to go along with what they were saying.

I recently created a Facebook-based TV channel called Penarth Social Media TV, which is a great way to collect exclusive local stories and checking the sources. Penarth is a small town with a population of 20,000. I can see people's profiles, I can ask around about these people, develop relationships with the community. I am much closer to the contacts who can tell me whether a story is true or not. When you post a story, everyone can comment and engage in the story, share it, add to it. It is a far more democratic, fair and open, and transparent process.

So let us compare that with the regional TV newsroom such as ITV Central in Oxford. I remember, in around 2006, a phone call I took from a barrister who told me he had evidence relating to the London Bombings in 2005. I passed it on to a contact at ITN, a chap called Michael Shrimpton, but I heard no more about it. The information he gave me sounded plausible but, at the same time, incredibly hard to believe. Michael now has a voice on social platforms and it is very interesting to hear what he has to say. Clearly the contact at ITN I passed his story to did not think his evidence was worth pursuing. I am certainly not going to pass judgement on what he had to say, that is for viewer to decide.

But it is interesting to see how it compares to the work I did on the hyperlocal TV station in Penarth, where I did feel more confident that a story was true.

But the truth is, in the regional TV newsroom at least, if you have a job such as a journalist, or doctor, or a solicitor, then you are more likely to convince those in the mainstream media to run your story.

I'll be honest with you. Most of the time working in a busy newsroom you have to base 80%-90% of your news on press releases, this is what the communications departments of public and private organisations tell you.

Organisations with money, who can pay someone to communicate with the media for them.

So, let's consider the impact that has on what we are hearing every day on the news.

We are hearing a version of events that they want to tell us. Is journalism about being told stories from big organisations or going out and finding them?

Journalists would always try to get case studies and reflect an alternative view. But the idea would mostly be generated by a government-run or funded organisation, companies who could afford PR, and large organisations with their own in-house public relations or communications teams.

Social media isn't like that. It is like all those calls we'd get every day being available to everyone. Social, those great juicy stories we couldn't cover because we didn't have the time to validate, can be available to everyone.

So I hope to be a truth-seeking journalist and a true journalist in the world of new media, who can empower everyone with the skills to be a great journalist.

The thing is, since everyone is doing it now, why not help them? And when I say help them, that is what this book is all about. It is not really about learning how to film and edit great shots like a pro, it is more about being fair and honest. Sticking to the principles of truth, fairness, justice, transparency. The BBC guidelines are a good starting place.

There are some fantastic journalists at the BBC, and I am not saying we don't need them, but let's trust our audience a bit more.

For example, the BBC will trust a press release from a government organisation rather than an unedited piece of video footage from a viewer. They are very careful in what they broadcast to make sure it is true, but why do they trust these communications departments so readily? At the end of the day these are PR people, spin doctors, they either have the true message or a distorted one from the person at the top, the head of the organisation. That could be a chief inspector in the police passing down a few lines to the media department, or the head of the military doing the same, or a big business such as Tesco or Marks & Spencer.

The mainstream media is NOT a reflection of society, it is a version – an interpretation created by spin doctors and PR companies, organisations who have the money and

time to foster relationships of trust with the mainstream media.

They provide a financially-stretched and time-poor media with an ever-flowing resource of news - news that appears to be true, news that is very nearly true. Well I say that but, honestly, who knows?

It is the public who know the truth, we need to rely on them more, trust them more, and give them the skills to do what we as journalists can't always do. I always felt I was missing a voice as a journalist, (and I was, I'd have just a few hours most days to do a TV report), but I no longer have to feel that way.

If people do lie, or manipulate or distort their message, then they will be found out and they will lose trust. That is how it's going to work from now on.

The BBC has cocked up on many occasions and covered stuff up, all organisations have, all people have. Jimmy Savile for example.

The mainstream media talk with authority, as if they have all the power, but they are losing it, and to address this imbalance I think passing on journalistic skills to the public is the way forward.

The most established news channels are defining the alternative. But it's a 'free for all' now, anyone can get their message on to these platforms.

We can all blog, vlog and podcast. We can buy a team of staff/reporters and start interpreting our world.

The Telegraph recently advertised a position for a video journalist, and I watched one of their reporters do a YouTube video reviewing the iPhone X. This video only had 600 views and it was of an inferior quality to what I could produce filming and editing on my mobile. The guy lacked energy in his presentation, but he was informative and professional. What was important about that broadcast was the brand, the Telegraph. That is what will sell news in the future, and convince people to believe – the brand and reputation.

BBC Radio Gloucestershire has just advertised for a video journalist, this is a radio show, looking for a journalist to film and edit on an iPhone or iPad. But it is radio? Confusing, isn't it?

All media is converging and viewers are seeking out the people and channels they can trust. But being able to trust someone is getting harder.

Think of YouTube channels with more than 30 million subscribers. We generally wouldn't call them the media, even though they are watched by millions all over the world every day.

I think the media means who we give our trust to, who has the authority to collate and summarise the news.

4 THE AGENDA

So let us examine, in more detail, what happens when the vlog becomes TV, the blog becomes an article, and the podcast becomes radio? What happens when you can't tell the difference?

I am devoting my career to teaching people how to make their video edits look and sound professional (whatever professional means?) - a better term might be mainstream.

I spent 11 years in the television newsroom. I learnt how to turn the non-visual into the visual with speed. I was often presented with a non-story, and had to turn it into a story (don't ask me right now about the truth aspect of that). But this meant I could pick out the visuals and the soundbites and turn them into a news package very quickly, ready for broadcast, sometimes within less than an hour from filming to broadcast.

Now in my 40s, and after a career break while raising children, I realised my passion now lay with teaching the public these skills, in an effort to promote transparency, truth, and diversity.

I do really enjoy YouTube – as much as the BBC, ITV or Sky, for example - because they are actually a true reflection of public opinion, because the content is created by the user.

The viewer can decide what is true or fake, what is drivel, what is engaging, intriguing, revealing.

As a journalist, all I ever wanted to do was communicate and discover the truth, to hold those in power to account, expose corruption, increase the rights of every citizen, and - which is the most important principle to me - that everyone's opinion matters.

I could watch Greg Dyke, June Sarpong, and Boris Johnson's sister Rachel, sitting around a table on Sky News discussing the various topics of the day for the Pledge, which I knew thousands were watching, and it is felt that their opinion matters to more than just them, as if they were reflecting the public's mood.

But I can see these voices are not reflective or diverse. They do not reflect public opinion, that disconnect has been seen in the way the mainstream media reported on Brexit, Corbyn, Trump.

There is a certain type of person drawn to being a journalist and this person thinks they know what the public think, but they don't. The point I am making here is that, neither do I. The public know how they think, so let's give them the tools to interpret their world.

So I teach them how to shoot and edit their own video news packages on their smartphones.

I teach them to be honest and fair, stick to facts and stories of public interest. I want everyone to believe they matter, and their opinion matters.

So let us consider what makes a journalist, and how I will argue that anyone can be one.

I studied anthropology and theology in a very small town in west Wales, I worked for Rothschild bank in the Channel Islands for two years, making rich people richer, through a system called gearing. Then I decided to become a journalist. No one else decided that I should become a journalist - I did.

To be honest, what drove me, and what I believe drives a lot of journalists, is ego.

I was pursuing the truth - yes, but I also had low self-esteem and loved the buzz of seeing my byline in the local paper.

I believe the ego has a huge role to play in the media today. I worked with some incredibly intelligent and passionate journalists over the years, but essentially they were getting the buzz of recognition that I think they all needed. If I am honest I enjoyed that attention, maybe part of me needed it.

We all love attention and recognition, but when that comes before the truth, then it distracts the public from the truth, because the media are distracted from the truth.

For example, every presenter I knew at ITV - straight after they had been on air - would rush to watch their bulletin back. They weren't getting on the phone,

chasing a new lead in a story, or meeting a whistleblower after work in a dark pub.

It was about watching their reflection, how did they look. Anyone who knows a little bit about psychology will know the importance of how we view the self, how we see ourselves, and whether our opinion of ourselves is realistic or unrealistic, positive or negative.

Do we like and accept ourselves, do we worry that past disappointments will repeat themselves, are we negative or positive about the future?

Many journalists, especially in the broadcast industry, need the ego boost, I know I certainly did. I found we all had similar stories. I, for example, had been very badly bullied at school at the age of 11. My female friends in the newsroom had very similar stories, someone had made them feel inadequate, whether that be an older sibling, friends at school, or perhaps a parent.

When you are a journalist, your opinion matters. When you are a journalist, you walk into the room and people look at you and they listen to what you have to say. When you interview someone for the news, you can see they are nervous. You suddenly matter, and if you have felt like you didn't matter as a child, that is very important.

And, at the end of the day, that is the essence of journalism. It is not just a reporting of facts, it is a collection of opinions. Opinions which they imply are an

accurate reflection of society... journalists think and reflect what the public think.

In the newsroom you get hundreds of stories a day. Why do you pick out certain stories to cover? Because they are relevant to the person sitting on the news desk? Because they are relevant to as many viewers as possible? Because they touch on a subject that affects the person on the news desk taking the call?

I was only able to see all this after I started training to become a psychotherapist a couple of years ago. When working in the newsroom, I just accepted it all as the status quo, it was simply the way things were done. The news was the news, and the news was true.

I am now a single mum of three and have experienced unemployment – this was after a long and successful career in the broadcast media. Am I a different person now, am I drawn to a different story? Yes I am. I have a richer life experience, but I still don't think I am qualified enough to set a news agenda for the day, to put together a half hour-news programme with a lead story and an 'and finally', because, by doing that, I am telling other people what is important, and that is not up to me. Neither is it necessary now, where we can access information from anywhere and everywhere.

I have worked in many news stations all around the country, and they give lip service to diversity. But, as a journalist, if we truly care about diversity, let's give everyone the tools to interpret their own world. Let the new news platforms be YouTube and Facebook, let us

guide people to be great journalists instead of telling them the news of the day. Truth, transparency, and accountability will be everywhere. Surely that cannot be a bad thing?

It is only now that I am beginning to see how the media defined and confined us. Is that a fair statement to make?

5 THE EGO

I studied to be a psychotherapist because I wanted to help people, and I realised the best advice I could ever give anyone in turmoil is to not give them any advice. And it is the same thing now - as a journalist, I embrace these fascinating topics of post-truth and fake-news.

Do not ask anyone what is true, you will know deep in your heart what is true. Work on listening to it, it is strong, it is the human spirit, and it will guide you to the truth.

What I have noticed, as I have been networking over the past three months in South Wales, is that a lot of people have been saying... 'I want to do video but I just can't bear to look at myself'.

I want to talk to them about doing close-ups, interviewing other people, and how to edit, but I keep hearing the same thing over and over again. They didn't want to ask me what mic or tripod they should buy, or what is a transition, or where can they get free-to-use music.

They would say: 'I don't like looking at myself back. I don't mind doing a voice-over but I don't like talking to camera.'

Now that is at the heart of live broadcasting, and using our phones to broadcast just like professional journalists.

Who likes to look at themselves and hear themselves, and who doesn't?

Broadcast journalists do like to hear themselves, and look at themselves. I did. I loved the attention, but does that give me the right to have an opinion that can influence society? Because, in essence, as a journalist, that is what you are doing, you are creating definitions that we all feel we have to abide by, or risk being mocked and shamed.

Let me explain that in a bit more detail. I turn up at a job, I decide the clip to use, I choose words to use in the voice-over and the tone of the piece. It is not impartial, as much as I try to make it. It is not balanced, as much as I try to make it. The problem I had with TV is that a lot of what I filmed was not visually exciting, so I had to ham it, spice it, spin it up.

I'd like to talk in a little bit more detail about working in a newsroom and how it all works, as I think this will help you to understand a bit about TV news and features.

I worked for both the BBC and ITV, the main difference being that ITV had about a third of the staff compared to the BBC, but produced the same volume of content.

When you work in a regional newsroom, there are limited resources. You have one job and you have to fill two minutes of the half-hour programme for that day. So if you turn up and the story isn't strong, you would have to make it strong.

The source of the story - the business, PR agency, or individual - may have written a fantastic press release and told the newsdesk, this and that would be happening, that it would be visually exciting and full of valuable and engaging content. Then you can turn up, and be faced with nothing that had been promised.

You can call the newsdesk and say this will make crap TV, or you can try to turn it into good TV. I have had to do that on many occasions.

However, now I am 41, and not 28, I'd be more inclined to say 'look this is poor telly of little value to anyone, can we not run it?'

But, even if I did that, they'd say 'Well, how are we going to fill that part of the programme? We HAVE to fill it with something.'

They used to have a few emergency news stories on the shelf, back in my day these were actually a physical tape that sat on a shelf. This was a ready-to-go, edited TV news package, a story that was not time sensitive and could be used to fill an emergency gap. But you would have failed miserably if they had to resort to that due to your own incompetence to deliver.

Generally, there weren't enough resources within the ITV regional newsroom to find something else.

So, this often-daily challenge I had as a reporter to turn valueless content into valuable TV was tough. I am talking about light and fluffy stories in the main, which

were a lot harder to do as a TV reporter than the stories when something had actually happened, like a crash, accident, or terrorist event. Those stories tell themselves, thanks to all the official releases that get sent through. But the end-of-the-programme piece – the 'and finally' - that is a lot trickier. You have to use real skill to make those stories engaging.

A skill I learnt and enjoyed, and I don't feel ethically I did anything wrong on these lighter pieces.

However, there were stories I was not happy with.

For example, I interviewed a girl of 13 who was involved in a high-profile custody battle. It involved her dad, who was in America, trying to get her back. It was high profile because her mum was on the phone to every newsdesk/news editor in the country. She allowed me to interview her child, but I felt it was totally inappropriate. The courts had decided that the father should have custody and she was asking her daughter to talk to me a TV reporter about how she wanted to stay with her mum

This happened when I was working in 2004/5 and I don't believe would be allowed now, at least I hope not.

It felt wrong, and I think that is an important lesson and message I can give to people reading this who are creating their own content, and want to become community and citizen journalists.

If someone is vulnerable, even if the person in charge of them says it is ok, it does not mean you should do the interview. Be strong and walk away.

When I was 27 I was keen to impress my bosses, but I lacked the courage and confidence to say no.

I remember going to a lead story for ITV in Birmingham and we were told a pet hedgehog had been kicked around like a football in the street.

I got to the address in Birmingham with around 10 minutes to spare before we went live. I looked at the little hedgehog, who was scurrying around quite happily, but he had a slightly bleeding scab on his nose. I realised that they didn't have anything else to lead the news bulletin on that night, so knew I would have to do it.

The presenter came to me live at the top of the programme, and I did my best. Interviewing the upset family who owned this pet hedgehog, (but not that upset, as the hedgehog was ok) and then I travelled back to the studio in Birmingham for the after-show debrief. Before I had a chance to sit at my desk, the news editor came over and said: 'Why didn't you just call us when you got there and tell us it was a non-story?'

The reason I didn't do that was because I was in my 20s, and didn't want to look like I had failed. On many occasions as a journalist I had put a lot of effort into making TV when there was no TV to be made, and had been congratulated. On this occasion however, they were right, they were very understanding that I simply didn't

feel I had the authority to question their choice of story. I didn't want to leave a big black hole at the top of the programme.

But, let's be honest, there were plenty of stories happening in the Midlands that day, a lot better than a slightly bruised pet hedgehog. Now there is social media, which can indicate what is really happening in a region, but only if people post.

They are still giving the power to larger organisations, but I really would encourage people to film and report what is happening in their areas.

Now, going back to the reason that I am telling you these stories, is so you can see how the regional TV newsroom works and how content is picked.

On the whole there is a news editor, a deputy news editor, who plan for stories on the next day and the week ahead, as well as reacting to any big news stories that day.

BBC regional TV newsrooms would have more future planning resources than this, probably someone dedicated to filling the diary. When I worked at BBC South Today, they had at least three people working full or part-time just on future news content. ITV just one or two.

But, on the whole, all of these stories appeared to be press release-based stories. Information passed to the newsdesk by businesses and organisations which had a

message they wanted to get across. They knew that if they told the story in a newsy way, for example, one in five old people are living in poverty, then tied that into some kind of freebie they were offering at an over 70s day care centre - 'we are handing out free jumpers' - then they would get that free advert. I am not in PR, so please excuse these lame examples.

There are PR agents being paid a lot of money to turn non-stories into stories to promote the businesses they represent.

Statistics and research are all a great way to get an angle into a story that isn't really a story.

Then there were the 'on-day' stories - fires, murders, accidents. I remember my boss Liz Hannam, the head of news in Birmingham, saying 'Well, we have had five murders in Birmingham today, this horrendous story in court, and someone else killed on the roads. But we are not going to tell our audience that, we need to be positive and talk about the community'.

And I was puzzled and thought 'Well. All that tragedy in one day, are we trying to keep the public's mood buoyant here'.

Do we tell them what has been going on in the Midlands today or do we tell them what they want to hear, or do we tell them what we think they want to hear?

Complicated, isn't it? How do we choose the news agenda?

I would want to know the truth. However, that day we didn't run all those death and tragedy stories. We did a few light fluffy features, such as a steam train museum and a school planting trees, and such a rosy balanced view of the world was portrayed to the people of the Midlands that night.

But was it a true and accurate reflection of what had happened that day? No way. It was a deception. A deception not a reflection, and all my life I have spent watching these programmes and they have had an impact on how I see myself and how I see society.

There is an arrogance about journalists and newsrooms which suggest we know how to portray the world, that information comes in and we choose how to disseminate it.

But it doesn't have to be that way anymore, does it? We all have smartphones, we can all interview others, talk about a situation we are in, then broadcast that via YouTube, Facebook, Twitter, or Instagram. I call these the new BBC, ITV, Channel 4. We can all broadcast.

We can interpret our own world. If we find something newsworthy, there is nothing stopping us from getting our mobile phones out and recording it, adding voice-over, writing links.

If it is a matter of huge public interest then we should be encouraged to. As only then will we be able to get a true and accurate reflection of what is really going on in society, and not the 30-minute regional and national

programmes played out at lunchtime, evening, and bedtime.

Come on, this is 2018 – do we really need these inadequate reflections on reality anymore? They are a sample of life, a sample of life chosen by people who deemed themselves adequate enough to be journalists – and journalists are the interpreters of the world.

If you want to stand as prime minister, I believe you have to ask Rupert Murdoch first, because, without his backing in the newspapers, forget it.

There are some fantastic journalists out there, and many of my former colleagues within ITV and BBC I hold in this regard.

When I worked as a journalist I fell into the trap of copying others, seeing how TV was made by more experienced reporters. I was told to mirror them. I would watch the way Mary Nightingale or Kate Garraway presented, and I would copy their intonation.

When it came to my reporting work, whoever cried the most, or appealed to my emotions and empathic responses, usually had the stronger voice in the piece. I was always balanced, I'd put both sides into every story. But there is a way you can write something that gives the person crying or upset the stronger voice.

I didn't do this on purpose and, only now, looking back at the age of 41, and having studied psychotherapy, do I see that I was not balanced, that I was prejudiced, that I did

have an agenda. I really don't think in a one-minute and 30-second package you can truly reflect a situation accurately.

On some American radio news stations they state what has happened, and then give two minutes over to each side of the argument to give their opinion, and that is the opinion of the people who have been affected. That way the journalists have not stated their opinion or said who is right or wrong. The people affected have simply stated their side of the argument and it is down to the viewer or listener to decide. Wouldn't it be great if all news media were the same?

The half-hour regional news programmes seem totally anachronistic now, out of context and dumped in the wrong decade. I can see why they were needed back in the era of the four or five channel TV world of the past, but surely not now. Why would there be a half-hour national and regional programme?

Listening to the BBC radio the other day, I knew there was no way I could work for them again. This was a news bulletin on BBC Radio Two, which led on a story of Wayne Rooney drink-driving, and the 'and finally' was the Kenyan elections.

Who decides that order of stories, which then tells us all that celebrities are more important than peace and democracy in Kenya? That is the problem with the media, that insidious everyday programming of what is important.

I feel like a global citizen, not pre-occupied with the national borders of countries mainly because I now watch a lot of global news. My identity is global rather than national.

When I have tried to watch say the BBC One lunchtime news, I struggle to connect with the content. For example, I really don't care about Tesco's or Marks and Spencers' rise in annual profits, (I buy everything online now) or the Queen, political squabbles, pressure on people to resign etc. Stories that seem to be consistently broadcast on these huge platforms, but why?

And why do I have to watch sport and weather on BBC News 24? Surely they can plonk that on another channel now.

I think the future has to be us, taking it over. We film the stories that are happening around us and we broadcast them on social media.

But it isn't two words anymore - social media - is it? it is just one word, the media. And that brings me nicely to the next chapter of this book - how to create your own TV channel.

I spent eight years working as TV reporter and presenter and I learnt the skills and techniques needed to make your idea look less vloggy, and at home on YouTube - more like the kind of content you'd see on BBC1, BBC2, Channel 4, and other news channels.

And I can do this all on my smartphone. And I can show you how to do it too.

I started creating content that had my professional TV voice on it, using a tripod and mic. I would interview people, get all the standard TV shots and started editing them on my smartphone, ready to broadcast. Because the stories were interesting, engaging, and looked professional, I was able to get a great audience on social media,particularly Facebook.

So this is the story of how I started my own local news TV channel on Facebook.

I had long been hearing amongst friends and ex colleagues of how the local news industry was dying, local newspapers closing on a weekly basis, not financially sustainable - and culls of over half of the staff at regional newspaper titles.

I want to suggest a business model for bringing back local news in a multimedia format, making it even more local – a hyperlocal news service.

In a way, by saying we don't need journalists and then showing you all how to be journalists, is a huge contradiction. My argument is that we are all journalists because we are all communicators.

There is a growing community of mobile journalists, using the #mojo hashtag on Twitter. But what is a mobile journalist? Someone who uses the device in their hand to

communicate the world around them? So that is basically everyone, isn't it?

The issue is, if we want to create a local news service that people trust, then with that comes a personal responsibility to check sources and provide balanced, accurate, and fair stories to our audience.

We can bring back local news, we can help to revive communities by making them aware of how the stories - such as local politics, events, and community news - affect them.

These communities already exist in the form of WhatsApp groups, email newsletters, and small hyperlocal Facebook groups.

As I mentioned before, where I live there is a parents' group on WhatsApp with 200 members. There is a village hub on Facebook with 1,000 users, and there is a retired chap who has collated 1,000 email addresses and sends out a daily newsletter of community news.

These local community news groups already exist in these many different formats, and there is a moderator or admin. They decide what content goes on, but on the whole they are open and transparent, people can post comments, and everyone is given a right to reply.

Isn't this a more transparent and diverse form of news and communication than say BBC local radio, which is just a one-medium news service, and a smaller team of unelected moderators.

What I would love to see happen is for every citizen in the UK to become a video journalist.

My courses teach people the skills they need to film and edit, how to take that information, and broadcast and publish it. Then there is the law and ethics, what music can I use, can I film someone if they are not aware of me filming them.

All of these issues are now incredibly important and guidance is needed. Rather than journalists trying to hold on to a power they have inevitably lost.

On the BBC lunchtime news today there was a news story about a growing concern for children being exploited by paedophiles during live streaming on platforms such as Facebook Live and Periscope.

Guidance is needed, and I think a set of rules put forward as a collective for the public to follow. I was in Lidl and witnessed two young girls under the age of eight doing a Periscope live without their parents or a guardian present. I have no idea what they were being asked or what they were saying.

What is happening on platforms like Facebook is that people are policing themselves, comments are put forward that guide each other on what is acceptable.

For example, I think you should always let someone know you are filming them. Now, for example, the BBC's Panorama has got some of its best stories by secret filming.

But can the public do that? I honestly think yes, why not? As long as it is a matter of public interest, such as someone being in danger of harm, and it prevents that.

It is the same in counselling and psychotherapy. In the BACP (British Association for Counselling and Psychotherapy) guidelines, confidentially is absolutely vital in the relationship between counsellor and client. The only time they break that is if someone else is at risk of harm, or the client is at serious risk.

I would apply the same principles to broadcasting.

6 LOCAL TV

Setting up my own TV Channel

The audience is there – you just need to create the content they want to watch.

I set up my TV channel by accident. I was going for a meal in a restaurant, which I had watched being built for about three years. I go jogging past there every day, and, like many of the locals, wondered what was happening and when it would open. It was literally sitting on the beach and I was surprised they'd got planning permission for it. I know the area quite well and had not seen many restaurants with such views and such privacy.

So, before going out, I called them and asked if I could do a piece, and they said yes. However, when I arrived, they seemed mildly reluctant, perhaps because they'd only just opened and weren't prepared for an influx of new businesses. Or maybe they were expecting a journalist to turn up with a camera crew, and not me with my iPhone.

I grabbed a free-to-use photo off pixabay, stuck Penarth TV on it, which is the town near to where I live, and I created a news page on Facebook. A hyperlocal TV channel - Penarth Social Media TV.

I posted a live straight into the page, interviewing the owner of the new restaurant. Then I filmed rushes (footage) for a full news piece, interviewing guests, filming the inside, the sea views, the manager.

Then, the next day, I got some shots of outside the restaurant, posted the piece, and within two days I had 14,000 views.

Yes, that's right, 14,000 views, AND 100 shares.

I found a story people were interested in, just by accident, and then there it was - the beast was created. Lots of people have done this, we find something people find interesting or funny and they watch and then share it. It is quite simple really.

I was playing a bit, I think, a project, a stunt to test. I was going out for dinner with my friend anyway, so I thought I'd film it as I was having a meal there.

That was the start of a new hyperlocal TV channel, and then I followed a simple set of rules, which terrestrial TV channels know all too well.

Create great TV, grow your audience, and then sell advertising. It is quite simple, and it works.

I looked at the advertising costs of local print publications that would be my competition:

- Penarth Times - £250-£350 a page, £160 half a page (average number of copies 3,500)

- Penarth View - £250 a page (average number of copies 1,000)

- Vale Life - £550-£650 a page (average number of copies 10,000)

I talked to local businesses about how much they were paying to advertise in these traditional print publications. I found out how many copies were printed, how many they claimed were read, and then thought about how I could show these businesses that their advertising budgets would be better invested in my digital TV channel which was broadcast to Facebook, YouTube, and Twitter.

My video views on that first piece surpassed all the other local media in 24 hours, but I kept telling myself 'I am just a journalist'. Yes, I know how to create great TV, but I have only ever worked for someone before, ITV, then the BBC, and the NUJ. I had never been in business, I had never worked and negotiated on advertising. I was lost, but could see I was on to something.

I started to learn all the terminology, marketing, digital, sales, in-bound leads, funnels, ROI, I am still learning. But I had something I could sell, going back to that basic principle again of creating something people want to watch, then attaching advertising to it.

The Facebook analytics were all there, how many people had been to my page, how many followers did I have, and, more importantly, how many people had watched the video.

I then built a 10-minute local news programme, as a pilot, without taking payment from anyone, then put £30 of Facebook advertising behind it and just delivered it to the people of Penarth.

The solo two-minute videos I was making were stand-alone, so I looked back to my old regional programme on ITV Central in Birmingham and realised that I needed to merge the reports together, put an ad break in the middle, and get a sponsor.

Like Coronation Street - it has a sponsor and an ad break.

I will never forget the old four-channel era and a wonderful, now retired, cameraman who I worked with who told me about the days when they'd be given huge wads of cash for TV work abroad. Those were the days, they used to say, a two-minute local news package would have a lighting and sound engineer, a reporter, and a cameraman, maybe even a producer too. ITV, they used to say, was given a licence to print money, with the Coronation Street adverts said to be bringing in something like £50,000 a second. It was very high as there was no competition.

So I understood the basic principles of advertising.

I needed sponsorship to include in the opening graphic, and I needed a mixture of free newsworthy content, and advertorial pieces. With my TV news background, I had the skills needed to make the non-story, a story, the non-visual - visual.

I presented the links from a location within the town. It was just like a mini version of the programmes I used to work on at ITV Central or BBC South Today.

And, yes, I wanted to be disruptive. This wasn't about me making money, this was about showing how we could all do that.

I didn't want stuff, and, now in my 40s rather than my 30s, I wasn't really interested in small-town politics. I wanted to write about it all, in this book, and show others that it can work.

In my 30s I was a TV reporter involved in regional news stories, and was very privileged indeed to talk to people with inspirational stories about their lives.

Now in my 40s, I realised they didn't need me to interpret their voice or message. They needed my help to show them how to do it effectively, to use their smartphones to create professional-looking TV. Encouraging people to be confident with their voice, their accent.

There were people at ITV who were criticised for their accents, a friend of mine had a strong Brummie accent and she was discouraged from presenting on air, yet at the same time they had huge diversity projects. It is a crazy world.

I could not get to every voice when I covered a story, it was not truly diverse. But now I could see, with the social media platforms to broadcast and the technology in their hands (the mobile phone), everyone could have a voice and contribute. Not just in a text or bloggy or vloggy way, but with voice-over, graphics, and storytelling.

Having just written that down in a few paragraphs, I still can't believe how this has happened and how simple it is.

Every town now has a community journalist, be that the admin or moderator of a Facebook group, or someone with a local blog. We have many in the area where I live in South Wales, many doing very well, without any journalistic training.

As a professional journalist you can sit back and mock these people, guffaw at how they keep getting it wrong, or you can try to help them. They will produce news content whether you like it or not, so I believe it is our responsibility to assist them in getting it right.

I really do think the future is more Facebook Lives and Twitter Periscope lives, in different locations. That is not something you can really get wrong. It is all there in front of you, from the horse's mouth, as it were. You can't misrepresent someone or misquote them.

I didn't have the money at the start to hire reporters to do social media reports, but that is where I wanted to head.

I also wanted to train students and schoolchildren to create great local news content that could then be posted to the channels I had set up.

Rather than it being the Anna show, this could be a real community effort.

But then I had the responsibility of dealing with it when it went wrong. This was something I was struggling to grasp.

As a news organisation, such as the BBC or ITV, there are policies and procedures for dealing with complaints, how you have to apologise if you get it wrong, and put things right.

So, if someone got information wrong, I could always rectify that with a comment. For example, on Facebook I said three cinema showings were in Penarth and actually one was in Cardiff. I just added that below the video to explain this error. No big deal.

In the about section of your Facebook page, you can list your rules for broadcast, your principles, and values, much like the BBC Editorial Guidelines – such as Accuracy, Impartiality, Harm and Offence, Fair News, Privacy, Crime, Politics, Young People. Have a policy on how to deal with complaints.

However, if I hired an untrained community journalist and they defamed someone or committed contempt of court and our only broadcast station was Facebook and YouTube, who is then responsible? The person who said it, me who has paid them, or Facebook for providing the platform?

That is an issue with taking on any staff, they represent you, and if they make mistakes the buck stops with you. Reputation is so important to me, the most precious commodity of the business, especially as trust is such a massive issue now when it comes to news.

I really do feel these hyperlocal stations need to be small and transparent, the people who run them, call them the

editors, admin or moderators, need to be open about who they are.

If they only cover stories relating to their mate's business, or report untruths, then the public can go elsewhere. The 'village journalist' can be like the local vicar or local doctor. In the larger organisations it is much harder to see who you are trusting – the producers and editors are behind the scenes.

The reputation lies within the brand. But I think that is really starting to erode when it comes to organisations such as CNN and the BBC.

There are many alternative news sources out there, challenging the 'truths' they have reported. People are confused and not sure where to go for their news, and who to trust. The smaller and more local the team, perhaps the more people will trust and rely upon it.

Is making great TV using your phone easy, and is it easy to emulate what I am doing? I think it is.

This book is in part about how I can train people to do this, how you can all have a TV channel. That could be local news, such as mini racing tournaments in Wales, the best restaurant in Canton in Cardiff, a Pontypridd pool tournament. It could be anything. Whatever you are passionate about.

So if people were to start doing local TV news channels on social media platforms, would they need a licence? No, it appears they don't.

Only if they have a schedule of programmes, otherwise they don't need a licence.

I am not licensed and I don't need to be, something I asked Ofcom about in the early days. Although, I will be honest, the information I was getting from Ofcom was vague and confusing.

It's not just about presenting well, it's about having the balls to chase a good story creatively and confidently. To spend time investigating, to interview people, to ask the questions.
But people aren't going to just let any old Tom, Dick, or Harry into their premises. If you are from the BBC or ITV, for example, those brands have a certain reputation. That is essential, someone giving over the power to interpret and then communicate their message, when essentially they have mobile devices and can just do it themselves. That is what it is going to come down to, who is going to collate the message.

But Social Media TV - the new channel that I have created in my home village - is about collecting all the news and great video into one place, then broadcasting it as a whole.

People said there is no money in local news, there is always money in great telly. Just concentrate on making great telly.
But does great telly sell? I am using techniques, that I guess PR people would use. Making a not-so-interesting story seem interesting.

For example, a friend contacted me to say that, in the village where we live, a campaign had started to bring the speed limit down to 20mph. He told me he would arrange for me to interview the various interested parties - local people, politicians, and local business owners. Well, yawn-fest, no thanks.

I immediately told him that we need someone who has nearly been run over. I knew that would draw people in. (I admit that I am still learning and making mistakes, I am letting the public guide me).

I then suggested they do some fundraising for a Facebook advertising boost. Create great TV with your mobile then put a boost on it, and you have a magic combination.

Small Facebook boosts of £10-£30 on each post were getting me video reach of 10,000 viewers. You can be very specific in who you target on Facebook. For example, I was commissioned to do a video for a company who make QR (quick response code) information pods, a very simple business idea that needed a video explainer. I asked the owner of the business who was his target audience, and he was very specific. He said practice managers within the NHS. So easy, that is who you target with your Facebook ad boosts. (The targeting following GDPR on Facebook is more general now, but you can target by location, which is perfect for hyperlocal news)

The video I did for this QR company took me just two hours to produce on my iPhoneX and, within a month, their sales had increased by 500% and they had to take on

a new member of staff. They had also attached the video to their email marketing list.

The problem I found is that people wanted me to do these videos for them, to put that TV newsreader voice to their message, and of course utilise that skill I had for creative treatment, that I learnt after many years working for regional TV news. I sound official, it sounds believable – it sounds as if this great product is actually on the news – so my reputation is attached to the business and the brand.

That is a common method used by advertisers and in marketing. Actors, journalists, presenters - either on-screen or doing voice- overs for a company - immediately cause an association in the audience between the individual and the product.

I charged very little for that video, and I am not interested in doing further work like this. It was a video I produced at the start of this journey and its purpose was to show HOW easy it is for ALL of us to create video like this.

I am not saying you will be the same standard after a one-day course, but you will get there.

We all tell stories in our day-to-day lives, we can all be creative. It just takes time, confidence, and perseverance. I truly believe everyone has it in them.

I didn't set out to create a TV channel on Facebook, I set out to be disruptive and to create a model that others could copy.

A hyperlocal TV channel is hard work. You need to build up your reputation and foster strong relationships with the local community, your advertisers, and the audience. You need to be reactive to local news stories as they come in and have the time to cover them. The media is habit-forming so, to start with, you need to provide a TV service for free. Then, as your audience builds and the public become more aware of your channel, the advertisers will be more confident to invest.

I published two magazine programmes, both lasting around 10 minutes, and for a £85 boost reached 22,000 video views on Facebook and 30,000 across all platforms to the right audience, i.e. the people of Penarth.

However, looking at my analytics, what was really interesting was audience retention. The average watch time was just 20 seconds. People do not expect TV on Facebook, it is a place to graze. Video on the newsfeed social media platforms, such as Instagram, Twitter and Facebook, needs to capture people's attention in three seconds, and, even if it is amazing, few people will get past the 45-second mark.

What I released, from trial and error and observing my analytics, was that I should have teased people on the grazing newsfeed, and provided the big meal – the feast of TV, the 10-minute programme - on YouTube.

I also expected too much too quickly. I was an unknown and was looking for advertising and sponsorship from the second programme. I think, after six months of producing the same type of programme once a month of consistently good quality and value to the viewer, then the audience would grow organically and there would be an expectation of great content.

Actually, in hindsight, I was incredibly lucky that the community put their trust in me, they trusted me to come into their shops, homes, and clubs, and interpret their world. This should have been enough and would have been enough to start with. Making that news service profitable is a long game.

So, here I am, I have produced two news programmes which had amazing reach for a very small ad boost.

It's not a simple case of beating the viewing figures of the Penarth Times and stealing the ad budgets businesses had set aside for them. As I am not established, I have no reputation

One of the biggest challenges I had to overcome was being a journalist and never having worked in business, being a little naive.

I had always had a regular but relatively low amount of money drop into my account every month with tax deducted, secure, regular, and someone else had to deal with business development, marketing, sales, advertising, brand reputation. I had never worked in PR, or

marketing, even though I know many journalists who have.

It is one thing to know how to create great content that people want to watch, it's another to make money from it.

So, yes, I was naive, and I have a lot to learn.

I was the content creator - the on-screen presence at the BBC and ITV - but there were so many other people who were a part of making that company work.

Now I was on my own, a solo producer, presenter, and businesswoman, trying to start a hyperlocal TV channel.

I'd listen to the local radio, and wonder how are they surviving on their ad revenue. Who scripts and voices those adverts for Trade Centre Wales, or a local plumbing centre? There has to be a direct correlation between viewing figures, or listening figures, and advertising.

But it isn't that simple, is it? Because, although the local paper - the Penarth Times - was only selling 3,500 copies (reporting a readership of 11,000) it was established and had been in the town for years. I had been around for about six weeks.

Yes, I had smashed the figures, but it is another matter getting businesses to part with their cash.

I could do a great programme in December, but a terrible one in February. I could hire someone else to do the presenting or producing, and immediately it does not get

the following it once had. The vehicle people thought they were investing in had changed. You lose trust at that point and your reputation nosedives.

The advice I had from so many hyperlocals, mainly in print, as the TV ones don't really exist in this country yet, is to prepare to do it for free for a long time.

Many started their hyperlocals as a hobby, a pastime, an evening and weekend job which they enjoyed. Community and citizen journalism is fun, and people want to know what is going on in their communities, even if it is just a burst water pipe that closes the road for a day and means you are late for work, or a local primary school getting a new head teacher.

The trick is to publish the news (be that through text, audio or visual) that people are talking about, that people are interested in. To tell it quickly, to let their voice be heard in terms of comments below the video, or readers' letters.

But, the most important thing of all, is accuracy and balance. Get both sides of the story and check, double-check, and triple-check, every single element... get the road name right, the person's name right, the date and the time right. You will quickly destroy your reputation as a journalist if you get any of this wrong. You will no longer become reliable, people will stop watching, reading or listening to you... and game over.

Building a reputation as a community journalist, with a valuable news service, takes time. Once people come to

you, as someone they can trust, then you are in a position to consider turning the project into a business.

Then the hobby becomes the day job, and that transition is a wonderful moment. It is something so many hyperlocal journalists have done, some with professional training, and some without.

But they all know the essential ingredients required.

There are others out there with a lot more knowledge than I on the print and radio scene. So I am not going to attempt to pass on any advice as far as text- or audio-based local news services are concerned, but I certainly can give advice and training when it comes to TV.

I am very happy to pass on the things I have learnt, the mistakes, the journey... from the very first day. To a large extent, this hyperlocal TV using your mobile phone has not really been done before, and it is a model I want others to copy. So I have to inspire and educate if I want others to copy, and that is my intention with this book.

Hopefully my journey will be of use, the ups and downs, successes and failures, the moments I was ready to give up. What works and what doesn't.

I am not a businesswoman, I am a journalist. So when it comes to sales, relationship building, negotiation, marketing, conversions, I was clueless.

I had no idea that these were all terms I was hearing for the first time at the age of 40.

I thought a lot of it was common sense, but I listened and asked questions and advice and I started to learn a bit more about business. And again, as I have already mentioned many times, if you create a product that people want to watch, the advertising revenue will follow.

7 FITTING IN

Relationship with other news providers

There will be other bloggers in the area, and it is a great idea to get on with them and, if possible, work with them.

I was approached by a local vlogger and blogger who owned a publication in Cardiff. This person was a very experienced former marketing manager from print who had run an events magazine, a printed version, which was now online. He had a strong Facebook and Twitter following, and wanted me to take a share of the business for creating content.

I was happy to do so, and our first few videos reached 10k video views organically. This was, I believe, more than he had ever got before.

But I was not offered a share in the business that I felt justified my talent, so I thought I'd go it alone.

I was happy to share my knowledge and experience, and we parted on good terms... we'd only been working together for about a week.

I gave him a tripod and recommended a mic for free. The two most basic and crucial pieces of equipment needed for hyperlocal TV.

And I kept an eye on what he was doing and the content he was producing.

He had told me that he was invited to press briefings and allowed into media-access-only areas. I found this really interested as, although he had a 14,000 following on Facebook, he did not appear to have any journalism qualifications. So, therefore, what qualified someone to get that kind of access?

He had an eye for a public interest story, such as a big restaurant chain opening a new branch in Cardiff, or Meghan Markle and Prince Harry's visit to Cardiff Castle just before they got married.

But the quality of audio and visual was not strong enough, and the main thing missing was storytelling. These stories would have made a good underlay, or OOV (out of vision). In ITV we called them oov and in the BBC we called them ulay. That basically means a 20-second story where the presenter reads over pictures. If there is no storytelling, you keep the story really short.

Examples of shorts:

- Gravy baby have opened a new store in Cardiff, there was a mile-long queue on opening day as everyone received a £10 voucher for a return visit.

- Prince Harry and his fiancée Meghan Markle visit Cardiff Castle today, and were greeted by thousands of onlookers.

These stories are not really three-minute stories. A few vox pops would work well on them, but they need to be kept really short or people lose interest.

This publication got to do an interview with a famous local chef, who had opened Michelin Star restaurant. The picture quality was very poor, and out of focus, and you couldn't hear what he was saying. There was no video layer over the interview, and there was no storytelling.

The problem you have is that you have done one video badly, and people are not very forgiving. Other local businesses would see that output, they probably wouldn't even allow you to interview them for free if they are portrayed in an amateur way. Many of us have teenage children that could do a better job. Simply putting your phone on a tripod and pointing it at someone and asking them some basic questions is not good enough anymore. Video done badly will turn off advertisers and the audience.

You need to take shots that make it look like you have two cameras, you need to cover parts of the interview with video of what is being talked about.

You don't need a top-quality camera, a smartphone used properly can do a very good job indeed. But it takes time to improve.

The publication in question has got a lot better, probably by looking at analytics and adapting accordingly, seeing what works in terms of views and engagement.

Video production companies charge around £500 a day to produce a simple video for a business or event. I have seen so many of these types of videos and the picture quality is superb, but that is about it, and they are

always the same. They have copyright-free corporate music, a video montage, where the shots change every three seconds, and an interview with the owner of the business, or organiser of the event. There is no storytelling and they are pretty drab and uninspiring, but I guess they are still better than a written press release?

There are a few things you can do immediately to lift a piece like this, such as vox pops if it is an event, or video testimonials when dealing with a business. So this piece on the chef and restaurant owner could have had short interviews, just five seconds long, of around four customer eating their lunch and saying how lovely it is.

A wide shot of the outside of the restaurant, a wide of the inside. There could be close-ups of the food, the table layout, the menu. This piece had none of that.

Find a case study, go into people's homes, find a business which has benefited from the product and interview them. Think about the visuals. such as a shop that sells fireplaces, go to someone's home and do a before and after of the new fireplace with wood burner, and then interview the customer very quickly about whether they like it or not. This is good TV. This sells. This could work as a feature or an advert.

Adverts can be interesting, but not something you are forced to watch.

The same principle applies to news and features. Always think in terms of pictures, and add short soundbites, vox pops, and interviews.

I'd say the same watching Made in Cardiff, a free terrestrial TV channel for the city of Cardiff. During the Christmas period they did a story on whether people knew what day it was – a good idea as Christmas had fallen on a Monday and people were back to work. With the bank holidays, it was confusing.

However, this report went on for far too long. It is a 60-second piece at best.

You can do a Facebook Live on this story and talk for 10 minutes, but it is cheap TV. If you start off doing this kind of TV people will soon turn off, you have damaged your reputation and they won't be tuning in again.

And if you work with another person, then you also take on their reputation. So be very careful about joining forces with someone until you know a bit more about them.

If you are doing hyperlocal, and the town is no bigger than a population of 45,000, such as Barry in the Vale of Glamorgan, then you can work on this on your own. If you are looking at a city like Cardiff, then you'd need to work with others. I would say it is too large a patch to work on your own.

After my brief working relationship with a few local bloggers, I decided to go it alone, and I started with the town that was closest to me.

The reason I did this was due to travel time - I knew I could be at any job within 10 minutes. I could arrange

meetings with potential clients, and cover any story, breaking news or otherwise.

Working on a TV channel for the area where you live has many benefits. It means you are more likely to find out about news stories on social media from where you live. You can build on relationships you already have... I knew the estate agents who sponsored my first bulletin. I knew where the shops were, the potential advertisers, and stories already, as I knew the area.

If you are working on this channel part-time then the stories need to be close by. This is not the case with print, as you can do a great story just by getting quotes over the phone. With TV, you have to be there.

In time I got a freelance cameraman to get my shots for the short stories, for example a new gym opening or planning permission given to demolish a building, an event taking place. You don't need a journalist to film these kind of stories. They can get you 30 seconds of rushes (footage) and you can then use the shots and write the copy.

You can then cover a lot in a news round-up. I would recommend a 60-second news round-up per 10-minute bulletin.

8 VIDEO OR TV

When is video TV?

I hear people talking about how important video is on social media and how important it is to increase your visual presence through Facebook Live. I couldn't disagree more.

It is about storytelling with video - which is television. A lot of Facebook Live broadcasts on my feed remind me of someone ringing the doorbell to your home and then standing there, proceeding to talk to you for 10 minutes about something you have no interest in. They will say hello to you now and again and eventually you will have to shut the door on them because they have nothing valuable to say. You feel rude for doing it, but you know that it is just a virtual closing of the door in their face, not a physical one.

Time is precious, so let's create visual content people actually want.

The live broadcasts, where the device is held in portrait mode and someone talks at you at length, is basically a very long piece to camera. There is no TV like this for a reason. Think of any TV programme where someone talks directly to the camera every day or every week, demonstrating a new product or talking about how to sell this or do that, or how to change your life.

A phone-in, perhaps with an agony aunt on This Morning for a minute or two, that would work. But I can't think of any other TV like this, because is it terrible TV.

It is narcissistic, mildly intrusive, and, on the whole, irrelevant.

The vloggy YouTube culture is mostly just a piece to camera, and that isn't very exciting. Once you have talked to the camera for 10 minutes, how can you then do it again and again?

What is your message the second time you do it? If it is a conversation between yourself and those in your group commenting, then it is like a telephone conversation or a Skype meeting.

It is not really video, and so many people are pushing others to do video on social media. However, at the end of the day, they are just sitting in front of a camera talking at you. This is not interesting. If there isn't TV like it, I always say don't do it.

If you could say everything you wanted and needed to say in your first social media live, then it is probably time to focus on something that is not you.

There is no mainstream TV that consists of people just talking to the camera. Yet, on social media, it seems the done thing.

Instagram TV is an example of this, I have struggled with this platform as it requires you to film everything in

portrait. Which then means only one person at a time can be seen close up.

9 BBC CULTURE

Reading this book, you may be thinking that my journalism experience has been limited to 2000-2011, and it has not taken into account recent changes in the newsroom, particularly in relation to social media, new research, production, and digital techniques.

My last job was at the BBC in 2011. I worked for BBC X-Ray in Cardiff, on a consumer programme that I would best describe as the Welsh version of BBC One's Watchdog. On this programme they had two presenters on a daily freelance rate (reported to be around £700 a day), who just presented. By this I mean that they did not find the stories, research them, write the presenting links, the voice-over scripts, or even write the questions to pose to interviewees.

This also goes for the one reporter for the show, she was involved a little bit more in the story, but the content was predominantly led by the producers and assistant producers.

There were many producers and researchers in the background, including a lovely lady who booked out all the hire cars, and filled in health and safety forms.

There was a huge team, and, comparing it to ITV, where I had been for many years, the contrast was startling. The same programme would have been produced on a staff of around three to four at ITV, but at the BBC, for a similar sized audience, the entire team was closer to 20 to 25.

I worked on this programme as an assistant producer full-time and was producing, on average, a single three-minute piece every two weeks.

I had to fill in a form for a hire car, or to book a crew, I had a whole morning to write the questions for just one interview. I had never seen anything like it.

I'd had a similar experience at BBC South Today in 2009 as the late presenter and producer. I started at 1pm but had nothing to do until 5pm, when I started to work on the 60-second news round-up. I actually ended up walking around Southampton buying baby clothes, or I tried to show that I was working by skim reading local news websites, pretending I was researching the news of the day. I wasn't from Southampton and, to be honest, I wasn't interested, but I enjoyed working there and didn't want to look like I was doing nothing.

If I had always worked for the BBC I probably would not have thought it strange, but I had been at ITV for many years, where we pretty much had to do everything on our own apart from filming (that has now changed and regional journalists, at ITV in the main, have to shoot their own footage too, as well as script and edit it).

Very often, at ITV in Birmingham, we would see a reporter and producer from ITN using our offices. I was always curious, watching how they worked. There would be a national news reporter covering a patch, such as the Midlands, and they would have a camera crew and producer. Any breaking news stories - and there were a lot in the Midlands - would be picked up by them on the day. It's funny, as I didn't want to work on the national news, don't ask me why. Maybe I thought I would say or do something stupid live on air and embarrass myself. Part of me didn't want the pressure.

The regional TV experience I had at ITV and the BBC proved to be very valuable, as I became a one-man band, able to do the lot. The national reporters and the BBC regional reporters, not really having to do everything, were missing those all-round skills. So, while at BBC X-Ray in Cardiff in 2011, that really stood out. I was the only person who could edit, for example. They paid a craft editor a freelance rate when, to be honest, the piece had already been edited by me.

They were a really lovely bunch of people there, and they asked me to stay on full-time. Unfortunately, I had to turn it down, but not because I didn't enjoy working with that team.

The editor at the time was a great leader, and had a sharp eye and talent for making great TV. She was very involved with the team and the programme, and the changes she made to my pieces were good. And I am fussy.

Of all the editors I worked for in television, I found her feedback and help the most useful and, more importantly, I learnt from her.

She asked me to stay on, but I had an offer of flexible part-time work with the National Union of Journalists and, as I was pregnant at the time with my second child, I felt this role – while not utilising my skills, talent and experience - was a better fit for this period in my life.

Around 18 months later, in 2014, I had a call and again - they asked me to go back to BBC X-Ray on a four-day week.

The reason I turned it down wasn't because of the pay, or trust concerns relating to the cover up of prolific paedophile Jimmy Savile (I wrote to Jim'll Fix It four times by the way, but never made it on!), or any other reason, other than it was just too slow a process.

I felt it was not good value for the licence fee payer, the content, the output, the whole process, was incredibly laborious. I felt the presenters could have been researching and presenting the stories. I felt the producers could have learnt how to edit. And, to be blatantly honest, I was producing one of those three-minute packages in a day at ITV, whereas it was taking two weeks at BBC X-Ray.

On my last week, I travelled with the main presenter to Swansea, to the Christmas markets, to do all of the presenter links. We had a camera crew, a lighting guy (I remember this well as the light fell on top of me!), and

then me - the producer/director - making sure the links were delivered with the right emphasis and intonation.

But, to be honest, I don't know why I was there. I don't know why the lighting guy was there. All the presenter needed was himself and a cameraman and, if he were a journalist and had been involved in the stories, then he would have been able to present the links perfectly adequately without any direction.

I compare this now to the presenter links I did for the 10-minute local news programme I produced on my phone. Where I set up the iPhone on my tripod, attached a £15 microphone, turned the camera around so I could see myself, and I filmed this in 4K. I honestly don't think you could tell a huge difference between this and the presenter links we did for BBC X-Ray.

I recently watched BBC X-Ray in 2018, and the same reporter I worked with was doing a piece on the spurious claims of various wine companies to have won awards, which are really just made up to get people to buy the wine.

Great consumer story, but I could again see the terrible waste of resources put into the production of that piece. She did several pieces to camera in different locations, then a wine tasting evening with all of her mates. Great free evening of copious booze for her friends, but not so great for the people forced to pay for a TV licence to fund such unnecessary extravagances.

I really would like things to change.

I understand that, with consumer issues, they do take time. This is not in any way a criticism of any of the people involved in that programme, I really liked them. You get used to a particular culture, and I have in the past. These were good professionals.

I also understand that they were working on highly contentious stories that needed fact checking to death. Teams of media lawyers poring over every detail - which is fair enough - and that takes time.

But it just was not for me. I definitely believe the process could have been a lot more efficient, and cheaper.

As my children got older, soon to all start at full-time school, I had that thirst to return to full-time journalism and I could have rung up my old boss at BBC X-Ray, or other contacts on the regional and national level of news.

But I had been watching too much YouTube. I did not think they were reflecting society adequately enough.

There was information out there on stories that were not being reported by the mainstream media, and I felt it was my duty to go off and do some digging. So I became a mainstream journalist, publishing on the alternative platforms.

But, more than anything, I wanted to empower community and citizen journalists and show them how to report these stories in an ethical and fair way. A way that would build trust in their audience.

At the end of the day, you can train to be a journalist in three months. (When I attended Highbury College in Portsmouth in 2001 I went for the nine-month broadcasting course, but the NTCJ, which was just three months of intensive training, was enough to get you a job in any print newsroom). So three months, it is not hard to be a qualified journalist, let's be honest here.

So yes, I know the newsroom has changed since I left, and I know in newspapers, for example, the online teams have taken over. In the TV newsroom there is, again, a huge online team.

Journalists are becoming multimedia, and other than in court (where you can't take recording devices) I am not sure shorthand has a role to play anymore.

Feasibly, every interview could be recorded and the public could be left to make up their own mind on the evidence presented, rather than the commentary and opinion that goes along with many news stories.

The sympathetic nod is one behaviour I see from TV reporters that makes me cringe. They often spend no more than an hour interviewing someone and then they have to do that shot - the noddy. An emotional and concerned look. But the truth is, they are in and out of that interview and then off to the next heart-wrenching story the next day.

I felt something was missing working with a number of TV journalists, there was a story there with all of them. A lack of completeness - something they were chasing

every day to boost their self-worth. I include myself in that description.

You may disagree with me, and that is absolutely fine. The future? I have no idea what that looks like, but I know the media will be taking a very different direction.

Maybe truth-testing journalists. Forced subscription news models with no advertising. I think hyperlocal TV could really work. Like I have mentioned before, where the local journalist is like the village doctor or school head teacher.

What I do know is that when I watch the BBC Six O'Clock News, for example, I feel like I am watching something very disconnected from the vibe on social media. That the lead stories, such as those on July 31, 2018 - on Brexit, British Gas losing millions of customers, volunteers bringing Wi-Fi to rural areas of Cumbria, and Stratford-upon-Avon having zero unemployment - is not what people are talking about. It has never become clearer to me that this is a huge gap between those journalists broadcasting the national news on TV and the trends and themes of public opinion on social platforms.

Also, let's look at what happens at the end of that national news programme, when the presenter says it's time to join the news team where you are. I am watching BBC Midlands Today, but I might live in North Gloucestershire, near the Herefordshire border, not in Birmingham, so what is happening in Wolverhampton or Rugby does not affect me.

The stories are not relevant – they are not part of those invisible boundaries of community to where we feel connected, they are not local to me - yet the advances in technology mean the BBC can provide visual local news, but are not doing so.

I produced a 10-minute news programme for the tiny town of Penarth in a couple of days, on my own, on my mobile, and it was far more relevant and engaging to the local population than the BBC regional programme that focused on Wales.

So what about investigative journalism.

Returning to that daily national news programme, I know how they work – the Channel 4, Channel 5, ITN and BBC daily news - they simply do not have the resources to research the big types of news stories, the ones I will mention in the last chapter, and then turn them around on the same day.

What often happens is that their larger documentary team, who have worked for many months and even sometimes years, feed them a two-minute news report to broadcast on the same day as their documentary goes out.

This has involved many meetings and preparation, people going undercover, secret filming, and every move being watched and vetted by a team of lawyers.

This is not something that everyday TV news reporters can report, it is not practical or achievable. That does

not mean they are bad journalists, it is just the reality of the daily news programme.

I contacted someone I used to work with, who is now a programme editor at ITN, in relation to a serious national news story. He said it is being covered by the Independent Inquiry into Child Sexual Abuse (IICSA), and had been reported in the Islington Gazette and the Guardian. But this was not true, the information was new and significant.

This person's news judgement is led by newspapers, as that is traditionally where TV news always went. They waited for it to appear in print, then they felt comfortable enough to follow. This is a 40-year-old who has been in a TV newsroom for 20 years. The first 10 years he was chasing the print front pages, every ITV Central News bulletin led with the front page of the regional dailies, the Citizen or the Gloucester Echo, back in 2004/5. I wish the TV newsroom would force themselves out of that culture.

But the reality is that perhaps the research and production teams are just not there to dig deep and investigate these very disturbing revelations. And, not only that, they don't have the experience either.

There were very very few ex-newspaper journalists in the TV newsroom – they usually put them on the newsdesk and they were very good and did what they could. But, on the whole, the TV newsroom was occupied by journalists who have only ever done TV.

From what I witnessed, up until 2010, the newspapers were the source of exclusives and the TV would follow the stories, and I don't believe they have quite snapped out of that tradition.

The TV newsroom, in my experience, lacks courage on the whole (and possibly the resources) to investigate and chase the exclusives. Which brings me nicely to the final chapter.

10 BOOSTING THE TRUTH

This is the closing chapter, and probably the most difficult to write, because in the past few months, before finishing this book, I have sent it to former colleagues and friends for feedback.

My pursuit of the truth and my passion for investigative journalism has steered me down an unexpected path. You may find this chapter a distraction and diversion from what you have already read, but it is very important to me that I include it.

I talk in this book about the power of citizen and community journalism, and how professional journalists have a duty to assist, by passing on their professional skills to help increase truth, transparency, and accountability within society. I very much stand by that.

It is one thing for me to show people how to present themselves confidently on camera. But, as I have already said, reputation, truth, and trust are more important than anything, as are making sure your reporting is accurate, fair, and balanced.

While I am thoroughly enjoying teaching marketing and communication professionals, small businesses, and students, how to use their mobiles to create TV, I know deep down I am an investigative journalist who wants to hold those in power to account.

That is why I am teaching people how to use the simple mobile phone to communicate the world around them. So this is where I come to talk about a man called Jon Wedger, who has, in my short life of 41 years, probably had the most powerful and disturbing story to tell. It is the kind of testimony that changes your life.

I first came across Jon on a YouTube link a friend sent me. He was talking at something called the ITNJ - the International Tribunal for Natural Justice, The Westminster Seatings - in April 2018.

Jon Wedger is an ex-Scotland Yard detective who worked for the Met police for 24 years. He received nine commendations and three service medals during that time.

He described how, in 2004, he was asked to investigate claims made by a 14-year-old girl - Zoe Thomsett - that she was being pimped out. This girl was in care, in a residential children's home. He looked into her claims and soon discovered she was not alone. In fact, within a few days he had found dozens of young teenage girls all with a similar story. All were subject to care orders, all had been groomed, given class A drugs to which they became addicted, and then became reliant on the pimp to supply. She died of a drug overdose, aged 17.

Zoe was not alone. Jon Wedger started looked into missing person's reports and discovered that, at weekends, children's homes were reporting dozens of young people going missing – they did their best to get them to stay, but they could not force them to. They

were required only to report it to the authorities and record it.

When he reported these finding to his bosses, he was threatened. Saying he would lose his job, home, family and access to his children. He claimed that no one was protecting the vulnerable in care, and the situation was out of control.

If you want to hear the whole story, I suggest you watch his 40-minute testimony on YouTube.

During his talk he mentioned someone called Lenny Harper as a fellow police whistleblower. Lenny led the investigation into Haut de la Garenne, the children's home in Jersey in the Channel Islands, which was excavated after concerns the remains of children lay undiscovered in its cellars.

After hearing his name, all of a sudden, I felt a shudder, something strong – a very powerful feeling came over me. I felt compelled to get involved, that is all I can really say. I really had no choice.

The reason for this is because, all of a sudden, this story came a little too close to home. I wasn't just watching crazy documentaries on YouTube, Jon Wedger mentioned someone I knew. I had worked at ITV in Jersey in 2002/3. I knew Lenny Harper, I also remember there had been some controversy relating to his investigation. I, like everyone else, had heard the mainstream media reports about the skull actually turning out to be a coconut shell.

However, I had never heard anyone describe him as a police whistleblower before.

Something inside told me I had to talk to him. So I did. When I worked in Jersey I used to attend the States of Jersey Police daily press briefings, and I had challenged Lenny Harper before. I was a good journalist, always trying to sniff out the truth. He was always very respectful and fair, even when challenged directly.

I also had dealings with the first minister at the time, Frank Walker, of who I am not able to say the same. I had challenged Frank Walker in relation to a controversial story where I had read the minutes of a meeting. I kept quiet and said I had not seen them. When I caught him lying about the information in those minutes, he stood up, red in the face, and started shouting at me.

I saw a different side to him – one I did not trust. Frank had a big part to play in the alleged obstruction of Lenny Harper as lead from the Haut de la Garenne investigation.

As I had not been living in Jersey or following the story, I did not realise that at the time, the head of the States of Jersey Police Graham Power, was removed from his post following the Haut de la Garenne Investigation. As well as Senator Stuart Syvret who was the Minister for Health and Social Services at the time. So the politician in charge of the relevant department and the first and second in charge of the island's police force were all removed. Then we hear the story that a bone was mistaken for a

coconut. Could the three forensic anthropologists on the ground make a mistake as big as that?

There were a lot of questions here for me, as an investigative journalist. I ended up interviewing the lead investigator Lenny Harper and Andrew Chamberlain, Professor of Bioarcheology at Manchester University, who was sent bone samples from Haut de la Garenne in 2008. Both of these interviews are on my social media platforms. I would highly recommend that you listen to them.

Professor Andrew Chamberlain taught two of the forensic anthropologists who were in Jersey during the investigation and said there was no way, they would mistake a bone for a coconut. He also confirmed that a bone he said was human, juvenile and burnt, was not the same bone that was carbon dated as being from 1600AD i.e. outside the area of forensic interest.

There is a lot of information here, and the investigative work I have done so far is extensive and the content for another book. In this last chapter, I mention all of this, because it is an essential final point to what is Making the News in 2018.

The relevance of these stories is that the mainstream media, by and large, has chosen not to cover the incredible testimony of these men.

So I am doing it myself, recording videos, putting them mainly on Facebook and boosting them, to enable the public to decide for themselves.

The live interview I did with Jon Wedger is now up to 560,000 views. I spent a day with Jon training him on how to use his mobile to capture other relevant testimonies, and he has now built up an excellent following on social media while he interviews fellow police whistleblowers and victims and survivors of child abuse.

The interview Jon Wedger recorded on his mobile with former Detective Constable Maggie Oliver (who was instrumental in exposing the grooming gangs in Rochdale) achieved 100,000 views in 24 hours. Jon is the journalist, no one else is involved.

Maggie's story has received mainstream coverage, in particular the BBC drama Three Girls. But Jon's has yet to receive that attention.

Don't forget, he is taking on one of the biggest police forces in the world.

When you hear Jon's story you may think that, if this is true, it would be validated by the mainstream media. Make headlines on the main news and be on the front pages of the national newspapers. Two BBC local radio stations interviewed him, and his story was in the Express, the Star and the Sun. The coverage was very low key.

But this is where I will end the book, with what I believe to be the most important point of all.

If journalists need someone in authority to corroborate the story - maybe a police whistleblower will come

forward claiming he was threatened to stay silent if he went public with the institutional cover up of child abuse - the newsdesk or investigative journalism research team would call the communications department of that institution, being the Met.

Would they say yes? This is all true.

No, of course they wouldn't. I know they would not because it was those in power who warned Jon Wedger he would lose his job, home, and family, if he went public with the information.

Mainstream news organisations need two sources to confirm a story is true before broadcast. Perhaps they could find some victims of abuse. Very often these people are damaged, a lot of them on drugs, and if there is any inconsistency in their statements they would not treat them as credible (although news reports have attempted to do this, and I have seen some great TV journalism around this, from the 1990s, in Islington in particular).

If these victims, who are almost always in care, have no parents, who is going to fight for them, who is going to care and shout and demand justice for them? Does this mean his story is not true?

Is this system of finding the truth failing? Journalists going to a communications department for an official statement. These statements come from those at the top - those who are guilty of the cover up in the first place.

So would the mainstream organisation run the story? Their documentary team might, but we are talking many many months of investigative work and even then the Editor might pull the story.

But what is important and what has changed now is that we can, I can, and you can.

Use your mobile device and boost with social media advertising to the people you want to reach. All I ask is that you listen to the testimony of these individuals - Jon Wedger, Lenny Harper, etc... and make up your own mind.

Journalism in the traditional sense is not really required here, the whole testimony is there without interpretation, decide for yourself.

If you look at the official viewing figures on the Broadcasters Audience Research Board (Barb) you may be surprised. The top 30 programmes of the week, in particular from Channel 4, have a similar audience to posts where I have placed a £100 advertising boost on social media.

I recently contacted the Head of News and Current Affairs for Channel 4, Dorothy Byrne, and Louisa Compton, the Editor of Channel 4's Dispatches.

They felt the Haut de la Garenne story was a very interesting one, but not new enough to return to in 2018. I felt disappointed to hear this, but then I checked the viewing figures for Dispatches and Channel 4 News, and

compared it to the viewing figures of the live broadcast I did with Jon Wedger, the police detective exposing the institutional cover up of child abuse, and they were comparable.

These are interesting times indeed. So did I need Channel 4? Are the public going to the alternative media and making up their own mind anyway?

Many would say 600,000 views on Channel 4 is far more powerful than 600,000 views on YouTube or Facebook? Perhaps that will one day change, as the trust shifts towards other broadcasting brands. For my generation the BBC, ITV, Channel 4 etc. still command reverence, respect and authority. However my children never watch these channels, they enjoy Netflix, Amazon and YouTube. They talk about the illuminati in the playground and discuss end of the world theories, as if they'd been on the ten o'clock news.

ABOUT THE AUTHOR

Anna Brees is from the Forest of Dean, Gloucestershire. She was born in 1976 and studied Anthropology and Theology at Lampeter University in West Wales. She started her journalism career in newspapers at the Guernsey Press in the Channel Islands, before moving onto television working as a reporter and presenter for ITV in Jersey, ITV Central in Oxford, Birmingham, Gloucester and Swindon. She finished her career at the BBC, as the late shift presenter and producer for BBC South Today and then as a producer for the consumer programme, BBC X-Ray in Cardiff. Since 2011 she has been training in new media, developing courses to help businesses, students, communication and marketing professionals broadcast professional video on social platforms.

Printed in Great Britain
by Amazon

88468R00059